Brian Webb & Peyton Skipwith

Harold Curwen & Oliver Simon

DESIGN

Curwen Press

Antique Collectors' Club

Design Series format by Brian Webb
Design, Harold Curwen & Oliver Simon, Curwen Press © Brian Webb
and Peyton Skipwith

World copyright reserved

ISBN 978-1-85149-571-9

British Library cataloguing-in-Publication Data
A catalogue record for this book is available from the British Library.

Antique Collectors' Club
www.antiquecollectorsclub.com

Sandy Lane, Old Martlesham,
Woodbridge, Suffolk IP12 4SD, UK
Tel: 01394 389950 Fax: 01394 389999
Email: info@antique-acc.com
or
116 Pleasant Street - Suite 18
Easthampton, MA 01027, USA
Tel: (413) 529 0861 Fax: (413) 529 0862
Email: sales@antiquecc.com

Acknowledgements
With thanks to Carol Unwin, Robert Simon, Mr & Mrs David Unwin,
Jeremy Greenwood, David Gentleman, Alan Powers, the grandchildren
of Max Rutherston, Eric Pumroy, Brynmawr College, Cambridge
University Library, Tate Archive and the estates of Eric Ravilious,
Barnett Freedman and John Piper

Picture credits
©Tate Archive p.25 © Estate of Edward Bawden
©Cambridge University Library p.36 top
©Brynmawr College p.72

The cover and endpapers are reproduced from Packing
Predicaments, 1931

Published by Antique Collectors' Club, Woodbridge, England
Design by Webb & Webb Design Limited, London
Printed and bound in China

GET THE
SPIRIT OF JOY
INTO YOUR PRINTED THINGS

THE WORLD'S dead tired of
drab dullness in Business Life.

GIVE your customers credit
for a sense of Humour and some
Understanding.

TAKE your courage in both
hands and have your printing done
CHEERILY!

I arrange & make
COURAGEOUS PRINTING
At the Curwen Press
Plaistow, London, E.13
Harold Curwen

To relieve the national weariness brought on by the First World War Harold
Curwen's belief was that well-designed printing that was a pleasure to produce
resulted in success for all involved, not least the customers of the Curwen
Press, 1920. The drawing is by Claud Lovat Fraser.

Design
Harold Curwen & Oliver Simon
Curwen Press

The creation of the 'Book Beautiful' was one of the driving ideals of the Arts and Crafts Movement, inspiring Cobden-Sanderson, Emery Walker, St John Hornby, C.R. Ashbee, and others. For them the perfect book had to be beautiful to behold and sensuous to the touch, like Morris's Kelmscott Chaucer; legibility was not a priority.

n a lecture delivered at Stationers' Hall in 1929 Oliver Simon, a partner in the Curwen Press, said that: 'Twenty to thirty years ago the finest and most ambitious books were produced by amateurs who owned private presses. Today I can confidently assert that the majority of the best books in England are produced by the trade, which in itself is a very satisfactory state of affairs'.[1] This was true. The finest books produced during the quarter century prior to the outbreak of the Great War were almost invariably printed by the private presses, but post-war, with the development of new technology, the accolade of excellence passed into the hands of a small number of commercial firms, with the Curwen Press very much to the fore. Like those earlier printers, Harold Curwen was inspired by the Morrisian ideal, but he did not adhere to the tenet that 'hand made' was necessarily better than 'machine made', which led him to become one of the pioneering figures in the technical revolution that transformed the printing industry.

The founder of the Press, Harold's grandfather, the Revd. John Curwen, an ardent advocate of the Temperance Movement, had, in 1844, been appointed Congregational Minister to the Independent Chapel in Plaistow, a quiet community about five miles from London. Prior to this he had spent brief spells

ministering in Basingstoke and Stowmarket, and whilst at
Stowmarket he had met Sarah Glover, a spinster who had devoted
her life to teaching singing through the tonic sol-fa method, and
this, combined with his preaching, was to be the Revd. John's
inspiration for life. He took to heart the message delivered at a
meeting of Sunday School Teachers in Hull in 1841, urging him
to devote his life to the 'cultivation of music in the service of
God', and twenty-three years later he resigned his ministry to
concentrate on the publication and promotion of tonic sol-fa
music through J. Curwen & Sons, the firm he had founded the
previous year.

During the period of his ministry at Plaistow the area had been
transformed from a rural village into a populous outer London
suburb, and it continued to grow for the remainder of the century.
This rapid expansion put an enormous strain on his ministry
necessitating the building of a new chapel and school, thus leaving
the old chapel building in North Street empty and suitable for the
installation of his printing presses. Up to this
point the printing of works published and distributed by the Tonic-
Sol-fa Agency, such as *The Child's Own Hymn Book* and *The Tonic Sol-fa
Reporter and Magazine of Vocal Music for the People* – or *The Reporter* as it was
familiarly known – had been done in Suffolk by John Childs & Sons
of Bungay, but printing was now transferred to Plaistow. *The Reporter*
was a monthly magazine which by 1864 had a readership of over
180,000, so this was no small matter for the Revd. John to
undertake. 'The monthly journal', as Herbert Simon wrote many
years later,
 … was the steady rock, the regular printing order on which the
foundation of the firm rested. For its production and sale at the
price of one penny everything had to be at hand to assist its
progress through the works. An ample supply of type for text and
display, special 'sorts' for Tonic Sol-fa notation were essential, as
was a foundry for casting printing plates from pages of type;
adequate printing machinery was installed of a size so that eight
pages of *The Reporter* could be printed at a time and there had to be

provision of sufficient bench space for folding, thread stitching and the heavily constructed machines for trimming away surplus paper.[2]

John Curwen's two sons, John Spencer and Joseph Spedding, both followed their father into the business although, if things had worked out differently, Spencer might have become the first Labour Member of Parliament. Instead he chose to sponsor his friend, Keir Hardy, as prospective candidate for the local constituency of West Ham South. The Revd. John, despite his dedication to the publishing and promotion of tonic sol-fa, was not particularly musical himself, but his elder son, Spencer, was a Fellow of the Royal College of Music. Not surprisingly, he was destined to devote his energies to promoting the music side of the business, whilst his brother concentrated on the printing. In those days printing was a practical business geared to getting the material off the presses and distributed on time, aesthetics playing no part. This was all to change, however, when Spedding's younger son, Harold, joined the firm in 1908.

The radical, non-conformist traditions of the Curwen family ensured that education was a matter of serious concern to the brothers, who were classic examples of the newly prosperous upper-middle-classes and pillars of the local Plaistow community. Characteristically, they rejected the idea of traditional public school education, which they saw as snobbish, promoting the established church, and perpetuating the ruling classes. In their eyes it was the natural breeding ground for 'Tory and Churchy young men' – to use a phrase of Hardy's – which was everything they despised. Instead, the brothers turned to one of the 'new' public schools, whose ethos was more sympathetic, and sent their sons to Abbotsholme in Derbyshire, which had been founded in the late 1880s by Cecil Reddie as a daring experiment in social fairness. It was at Abbotsholme that the young Harold first learnt carpentry, printing and agricultural husbandry and came across the ideals of the Arts and Crafts Movement. After leaving school in 1903 Harold decided to learn the printing

HAROLD CURWEN OF THE

CURWEN PRESS

has studied under one of the editors of this Magazine, as well as under other leaders of the movement for improving the style of commercial printing.

THE STAFF OF THE

CURWEN PRESS

has been trained so that it is able, with the present-day materials, to produce the best results in artistic and forceful Catalogues, Show Cards, Pamphlets, Labels, etc., and also in the printing and binding of beautiful books of every description.

Mr. Curwen requests permission to call at your address, or to send examples of his work executed at

THE CURWEN PRESS,

Plaistow, London, E.

'Phone: EAST 1737 (3 lines).

66

The Curwen Press 'manifesto', a full page advertisement published in the first number of *The Imprint*, January 1913. Harold Curwen had studied under Edward Johnston, one of *The Imprint's* four editors, at The Central School of Arts and Crafts.

trade from the bottom up. He started as an unpaid assistant in the family business and then went to Leipzig, where he worked for Oscar Brandstetter, a famous old firm of music publishers, with which his family had had long connections. By happy chance, his time there coincided with the publication of the Insel Verlag editions of the classics, the production of these volumes being supervised by Emery Walker and the title pages drawn by Edward Johnston and Eric Gill. Their appearance demonstrated clearly to the young Curwen that 'the care and simple beauty of the Doves Press could be applied to mass production'.[3] So, with his aesthetic awareness aroused, he returned to London and enrolled at the Central School of Arts and Crafts to study calligraphy under Edward Johnston. Johnston was an inspiring teacher and pioneer in the revival of calligraphy and the reform of typography; ninety years on his sans serif design for the London Underground, which was to exert an immense influence upon the future of lettering, still remains one of the twentieth century's most influential and legible typefaces.

Johnston was not alone in his enthusiasms. The example of the Kelmscott, Ashendene and Doves Press, coupled with the proselytising influence of such figures as Emery Walker, Cobden-Sanderson and W.R. Lethaby, inspired a generation of young men for whom fine printing became a sort of holy grail. This was not just an English phenomenon; it swept through Germany, Holland, France and the United States, leading to an international camaraderie and friendly rivalry between the different printing houses, with regular exchanges of ideas and specimens.

In 1908, having completed his studies at the Central School, Harold joined the family firm, becoming a director three years later. Although personally inspired by the ideals of the Arts and Crafts Movement, he was sensitive to the fact that among the highly skilled craftsmen at the Press, many of whom had worked there all their lives, there was a deep distrust of change.

As Herbert Simon says: 'Visual appreciation was almost non-existent and far from anyone being influenced by the Arts and Crafts movement it is unlikely anybody had ever heard of it. The printing of the Kelmscott Press, the work of Emery Walker and Cobden-Sanderson at the Doves Press and the calligraphy of Edward Johnston were almost certainly, as far as Plaistow was concerned, unknown except to Harold Curwen'.[4] In these circumstances, and given the paternal ethos fostered by Spencer and Spedding Curwen, Harold had to progress with caution. In 1914, however, with the outbreak of war, he took over the management of the Press, which eased his task of persuading the old hands that his aesthetic ideas were not only right, but were good for the firm. One who remained unpersuaded was the manager, Sidney Barras, who was given two months' notice and a generous severance payment of £300, whilst Harold himself assumed his work. Apart from resistance to new ideas by some of the craftsmen, a further hindrance to the speedy advancement of his typographic revolution was the fact that prior to 1914 the typefaces and decorative material in the composing room were seriously uninviting.

One effect of the rapid changes in printing technology was the growing number of journals devoted to printing and typography; amongst the earliest of these was The Imprint, edited by Ernest Jackson, J.H. Mason, Edward Johnston and Gerard Meynell, which first appeared in January 1913. Harold took out an advertisement in the initial issue in which he proudly proclaimed that he had studied under one of the magazine's editors and announced that 'The staff of the Curwen Press has been trained so that it is able, with the present-day materials, to produce the best results in artistic and forceful Catalogues, Show Cards, Pamphlets, Labels, etc., and also in the printing and binding of beautiful books of every description'. The second issue included, as an insert, a striking four colour image, Arkwards by Ruth Vaughan-Stevens, printed at the Curwen Press. Harold, presumably, was also the author of the article 'Colour Printing',

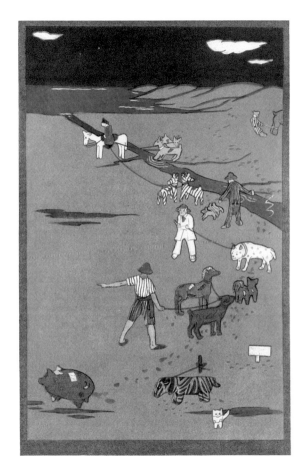

Arkwards by Ruth Vaughan-Stevens, printed from four letterpress line blocks supplied by the Anglo Engraving Co. as a demonstration of Curwen colour printing, in the second number of *The Imprint*, 1913.

which appeared over the initials 'H.C.' in the April issue, and possibly the anonymous scribe who wrote up Carl Hentschell's address on the 'Methods of Illustration and the Preparation of Blocks for Technical Papers' in the same issue. What is notable from these early appearances is that he had already made considerable progress and quickly gained the respect of his peers.

For someone as introverted and shy as Harold, persuading both his fellow directors and the workforce of the rightness of his vision must have taxed his powers, but perhaps it was a combination of his own faith in his mission and the gentleness with which he expounded it that won over all but the most recalcitrant. An account of him with a group of friends on a ski-ing holiday in Switzerland at this time paints a picture of a humorous, gentle but resourceful young man:

Harold S Curwen. Better known as the universal "Mr. Bubbles." Leader of a Boy-scout rabble. His useful and unlimited knowledge of checks to all emergencies was invaluable. 6ft.3in. in his socks, therefore able to see bad weather coming over the mountains and cobwebs in odd corners of room and mind where they should not exist. Deputy stoker to Bachelor's Suite. Corrector of Bad Girls. Leader and Chronicler of the famous Survivors. Maker of human Jig-Saw puzzles and carrier of enormous knife of world-wide renown...Came out of his shell twenty-four hours before our departure, and lost it twenty-four hours after.[5]

Although the tone is affectionately mocking, and some of the references are in-jokes, it shows Curwen as a resourceful companion and team-player. As is clear, he was a passionate advocate of the newly-formed Scouting Movement, which he regarded as character forming: 'What finer lead can you give a boy than to help him to do a kind act to somebody every day?' he wrote in *The Old Abbotsholmian*, exhorting his former schoolmates to follow his example; and members of the staff in Plaistow recalled that during the Great War the entrance lobby to

the works in North Street was appropriated several evenings a
week by 'Scoutmaster Harold Curwen' and his troop.

Given the family's religious and political beliefs, it is not
surprising that Harold's attitude to war was similar to that of the
Quakers; although not a pacifist he was only prepared to serve
his country in a non-combatant role. Thus in 1914 he added
service with the Special Police to the duties of scoutmaster and
running the Press, which, despite the drastic depletion of staff,
was now busier than ever. By 1916 he had instigated a general
replanning of the works and, aided by the staff shortage, felt able
to push ahead with the installation of modern machinery and the
development of new technology. He was in the forefront of the
development of offset lithography, which ensured that the
Curwen Press would be in the vanguard of fine colour printing
throughout the next decade. Circumstances also enabled him to
present the modernisation of the works as an act of patriotism as
well as sound business. As a contribution to the war effort he
sold off the bulk of the old typefaces, an act which not only
helped to ease the national shortage of lead but enabled the firm
to benefit financially from the highly inflated price of scrap-
metal. In this way he 'sacrificed' over two hundred of the
Victorian typefaces he most disliked, retaining for general use
only Caslon Old Face, Monotype Old Style No.2 and Modern
Wide No.18. Not even the most die-hard traditionalists on the
staff could object to this patriotic action, which in one fell swoop
cleared out more than half a century's accumulation of long-
forgotten formes. He was enthusiastically putting into practice
the course of action advocated by Joseph Thorp who, in the May
1913 issue of *The Imprint*, had written an impassioned attack on
bastard letters with their 'bulges and flourishes' resulting from
misapplied ingenuity.

A somewhat surprising event took place in March 1915, which was
to have a profound effect on Curwen and other like-minded
designers, architects and businessmen; this was the Board of Trade

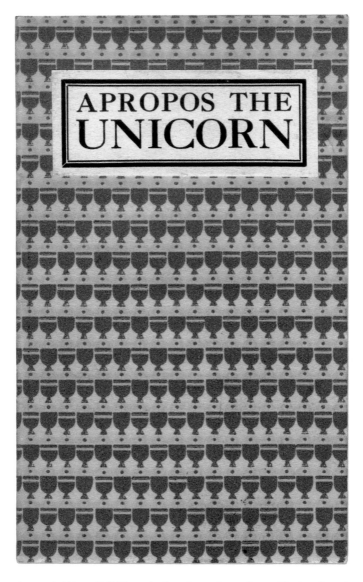

Apropos the Unicorn, 1919-20, was the first of many Curwen Press publications. Expertly printed by Curwen, the little book was written by the exuberant Joseph Thorp who counterbalanced Harold Curwen's natural diffidence. The cover pattern was drawn by Lovat Fraser and the book contains illustrations by Lovat Fraser, Macdonald Gill, Aldo Cosomati, Dorothy Mulloch and Phœbe Stabler.

sponsored exhibition of well-designed German manufactures held
at Goldsmiths' Hall, London. Shortly before the war the *Werkbund*
exhibition in Cologne had demonstrated that German
manufacturers, having no reservations about mechanisation, had
pushed their country firmly into the forefront of industrial
production. The *Werkbund*, whilst inspired by the English Arts and
Crafts movement, saw no dilemma in adapting Morrisian ideals to
the machine. The immediate result of the Goldsmiths' exhibition
was the summoning of a public meeting and the setting up of the
Design and Industries Association – DIA – of which Harold became
an enthusiastic founder-member. Among the most active leaders of
the DIA were Ambrose Heal, the architect Cecil Brewer, Harold
Stabler – silversmith and partner in the Poole Pottery – Frank Pick
of the London Underground and Harry Peach of the Dryad
Workshops. Over the ensuing years the Curwen Press was to
produce work for many of these, but the DIA member who was to
have the most immediate impact was Joseph Thorp, writer and
publicist, who became a friend and adviser and, at the end of the
war, joined the staff of the Press as a consultant. Thorp introduced
Curwen to Claud Lovat Fraser, whose psychedelic vignettes in
yellows, vermillion, aniline greens, carmine, cobalt and
ultramarine were to become almost a hallmark of the Press,
adorning labels, letterheads, pamphlets and, later, books. 'Get the
Spirit of Joy' is one of the earliest examples of the revolution that
Curwen was bringing about – beautiful printing for the sheer hell
of it. Thomas Balston recalled that, in those 'colourful and long-
ago days of Lovat Fraser broadsides and Poetry Bookshop
manifestos, the beautifully printed and well-designed leaflets,
booklets and books of Mr. Harold Curwen and the late Gerard
Meynell of the Westminster Press were the lively and vigorous
voices of militant pioneers'.[6] Harold may have been a gentle
militant, but he certainly did not hesitate to describe himself at
this period as 'a rebel against commercial ugliness'.

Europe, having just emerged from the grimmest and bloodiest
war of all time, was ready to shed 'drab dullness', but not

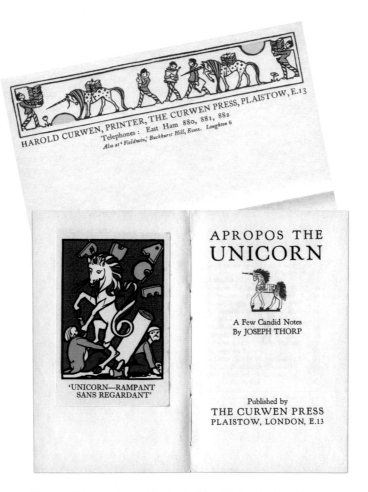

The 'tipped in' frontispiece by Macdonald Gill and Unicorn by Lovat Fraser.
Thorp wrote: 'I like that Unicorn of Curwen's. I see him (or her – the sex is
doubtful) in my imagination (which is a riotous one) impaling on the point of
his (or her) resolute horn (as the park keepers do) bad bits of printing and bits
of bad printers, and pushing them off with an angry hoof into gigantic waste-
paper baskets.' Harold Curwen's letterheading shows his Unicorn working from
morning 'til night.

everyone was pleased with the changes Harold was bringing about. The directors of The West Ham Tram Corporation, previously one of the Press's biggest customers, were so incensed at receiving a batch of note headings neatly printed in Caslon, rather than Haddon Condensed, that they cancelled their contract. However, Joseph Thorp's extrovert approach to publicity, along with new and sympathetic contacts made through the DIA, helped refill the order book. One of Thorp's first innovations was to persuade Harold that the Press needed a printer's sign or trademark. Thus the Unicorn came into being as the ubiquitous symbol of the Plaistow works and Thorp immediately penned an elegant promotional booklet, *Apropos the Unicorn*, lauding the virtues of the Press. Thorp – 'Mr "T" of *Punch*', as he was known – was never backward in promotion, both of himself and others whom he favoured, and in this little book he proclaimed: 'I believe the Curwen Press to be producing today the best business printing in England, simple, direct, distinguished, intelligent, individual and adventurous'. No mean boast, but both he and Harold passionately believed that all printing, be it a trade card, a letter heading or a label, should be carried out to the highest standard possible, with the result that the Curwen Press was to produce some of the most beautiful printed ephemera of the period. The original unicorn was drawn by Paul Woodroffe, but over the years it was recreated in many guises by Eric Gill, Lovat Fraser, Percy Smith, Aldo Cosomati, and others.

The next momentous event in the evolution of the Press was the arrival in 1919 of Oliver Simon, a nephew of William Rothenstein, Principal of the Royal College of Art. The Simons had hoped that their son would go into the family cotton business in Manchester, but on a visit to London he saw a Kelmscott Chaucer in the window of Sotheran's, the antiquarian booksellers in Piccadilly, and, in an almost Damascene conversion, realised that books were to be his life. Another uncle, Albert Rutherston, who had anglicised his name during the war, introduced him to Claud Lovat Fraser who, in turn, introduced

him to Joseph Thorp, through whom he met Harold, who offered him an apprenticeship at Plaistow. Although very different in character, the two men clearly got on well together and after a year Harold offered Simon a partnership in the firm, giving him the specific charge of bringing book business to the Press.

Harold, who had rushed about the country on a motorbike during the war to see clients and drum up business, now felt able to remain ensconced in the works at Plaistow, whilst Oliver established himself in a West End office, first of all at St Stephen's House, Bridge Street, Westminster and from 1924 at 101 Great Russell Street, Bloomsbury. Once established, he could visit friends and potential clients to discuss books, printing and artists. He was a sort of front-man for the business, discreetly touting for custom. His brother, Herbert, described him as 'the firm's most uncommercial commercial traveller', as he eschewed the direct approach, preferring to go in for what he called 'infiltration'.[7] The office in St Stephen's House was still the London base of the Cloister Press, managed by Stanley Morison, and the friendship established between Simon and Morison at this time was destined to have a momentous impact on the printed page. Under their influence, and with the enthusiastic encouragement of Francis Meynell, Oliver's office became a sort of 'private university of printing' as he described it, and it was here that The Fleuron – the most influential English typographic journal ever published – was conceived. The Fleuron was not intended to be a long-running publication and only seven issues were to appear, the first four volumes (1923-25) being edited by Oliver Simon and printed in Plaistow, whilst the final three were edited by Morison and printed at the Cambridge University Press. Another result of these sympathetic gatherings was the founding in 1924 of the Double Crown Club, a dining club for those involved in fine printing, which still flourishes to this day.

Prior to embarking on the first issue of The Fleuron, the Curwen Press had produced several rather more modest volumes, starting

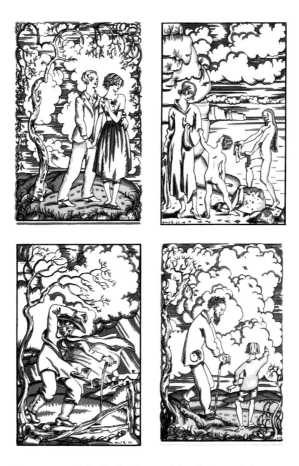

Four page proofs for *The Four Seasons*, Albert Rutherston's first illustrations for Harold Curwen and Oliver Simon. In October 1922 the Press took over the offices of the Cloister Press in Westminster, where Stanley Morison was typographic adviser. The pocket sized calendar, published in December 1922, contains a Curwen Press composing room type list, pages offering Simon's views on 'printing as an art as well as a craft' and on the use of decoration.

with a poetry anthology, *The Lute of Love*, and Charles Nodier's *The Luck of the Bean-rows*, both illustrated with vignettes by Lovat Fraser. The first edition of *The Luck of the Bean-rows* was printed by Gerard Meynell at his Westminster Press, but, before it had even appeared, the publisher, Daniel O'Connor, decided, rather over-optimistically as it turned out, that he required a further 30,000 copies in time for Christmas and approached Simon. It was an order that Curwen was only able to fulfil by running the presses day and night, but, despite this pressure of time, the fastidious Harold insisted on remaking the blocks and personally overseeing the inking in order to get the greatest possible richness into the black as well as the colours. The same is true of one of their next books,*The Woodcutter's Dog*, published in 1922, which was another Nodier reprint for O'Connor.

1922 was the beginning of the Curwen Press's golden decade, during which it produced, in addition to *The Woodcutter's Dog*, the English language edition of Julius Meier-Graefe's two volume biography of Van Gogh for the Medici Society, the exhibition catalogue of books and manuscripts for The First Edition Club, Goldoni's *Four Comedies* and the delightful little pocket engagement book, *The Four Seasons*, illustrated by Oliver Simon's uncle, Albert Rutherston. Rutherston was later to illustrate Thomas Hardy's *Yuletide in a Younger World*, the first of the Ariel Poems for Faber & Gwyer which were to become a feature of the collaboration between the two firms. In addition there was the 'Safety First' Calendar, issued in conjunction with the DIA, which ran, rather curiously, from September 1921 to August 1922, and was adorned with Lovat Fraser's cautionary illustrations.

Oliver Simon's regular calls took him round the offices of Frank Pick at the London Transport Board, the Meynells – Gerard at the Westminster Press and his cousin, Francis, at the Nonesuch – and Stuart Menzies at Stuart's Advertising. He also went to see Ambrose Heal at his eponymous store in Tottenham Court Road, Harold Stabler of the Poole Potteries, William Rothenstein at the

Royal College of Art and Jack Beddington at British Petroleum. Cyril Connolly, who had witnessed such visits, in his review of Oliver Simon's book, *Printer and Playground*, recalled: 'Mr Simon would enter the office about tea-time with a smile and a kind word for everyone, his pockets bulging with ornate borders and swelled rules, his friendly, fastidious, mildly inquisitive face suggesting some popular padre arriving at the canteen'.[8] However, as he went on to say, once the initial courtesies were over, they were frequently followed by an explosion of wrath, occasioned by some offending manuscript or *bastard* piece of typography.

In addition to these sociable rounds, with the establishment of *The Fleuron* Simon's office became an international meeting house for anyone interested in typography and the art of printing. Although the actual words 'typography' and 'typographer' had been in use since the early seventeenth century, it was only now, as printing changed from hand-craft to machine production, that there grew a demand for the skills of specialist typographers. The four issues of *Fleuron* edited by Oliver Simon were, both in production and content, standard-bearers for this new art. The first issue included articles on 'Printers' Flowers and Arabesques', 'Initial Letters and the Printed Book', 'The "Lost" Caslon Specimen of 1748', and 'Printers' Marks', whilst the second contained Stanley Morison's important essay 'Towards an Ideal Type'. One feature of *The Fleuron* was the binding-in of fine examples of original illustration and typography from other presses, a practice which had been pioneered pre-war by *The Imprint* and *The Penrose Annual*. The third volume contained bound-in samples from Czechoslovakia as well as John Drinkwater's poem *Christmas Eve* with a beautiful illustration by Albert Rutherston, who had by now become a regular Curwen artist. In 1930 he illustrated one of the Press's most ambitious productions, a critical edition of *The Haggadah*, for The Soncino Press, with the story of the Jews' flight out of Egypt, the central text for the Night of the Passover, printed in both English and Hebrew. The English text was printed in Monotype Baskerville, whilst the

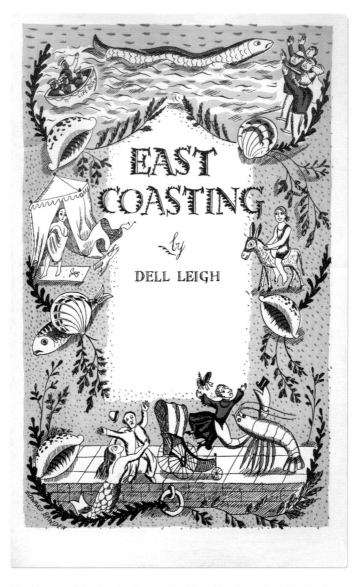

The title page of *East Coasting* illustrated by Edward Bawden, and published by the
London and North Eastern Railway, 1931. The booklet was written by Dell Leigh
(EP Leigh Bennett) who wrote…'purposely was there no set order of travel; one
merely coasted carelessly by, looking at life.' Bawden merely let his imagination run riot.

Hebrew was composed by Enschede en Zonen of Haarlem in their sixteenth century Canon Hebreeuws.

Curwen's 'Orders and Payments to Artists' book exists for the years 1926-33[9] and lists over two hundred names including Mary Adshead, Edward Ardizzone, S.R. Badmin, Dora Batty, Edward Bawden, Margaret Calkin James, Aldo Cosomati, Irene Fawkes, Barnett Freedman and his wife Claudia Guercio, Eric Gill, Dorothy Hutton, McKnight Kauffer, Enid Marx, John and Paul Nash, John Piper, Eric and Tirzah Ravilious, Rutherston, Phœbe Stabler, Reynolds Stone, Graham Sutherland, Betty Swanwick and Feliks Topolski. Not all the names on the list are those of pictorial artists; some, such as EP Leigh Bennett and Hamish Miles, were writers who contributed texts to promotional brochures such as *Match Making* and *East Coasting*. The painters, draughtsmen and engravers, however, did an amazing variety of work – labels, trade cards, note headings, prospectuses, bills, cheques, timetables, books, posters, pattern papers and wallpapers. Never before had so many artists been able to augment their earnings in this way. Central to this artistic activity were five people – Harold Curwen, Oliver Simon, Frank Pick, Jack Beddington and William Rothenstein. Under Rothenstein's direction the Royal College of Art had truly become the design school that Prince Albert and Sir Henry Cole had envisaged, three-quarters of a century earlier, as arising out of the Great Exhibition. The influence of the Arts and Crafts movement was still strong at the College, but so was the ethos of the *Werkbund*.

A number of these artists spent a day a week at Plaistow: Irene Fawkes illustrated booklets for a firm of mattress-makers, Dora Batty for a wholesaler of watches, Dorothy Hutton, who went on to become a calligrapher of renown, designed amongst other things one of Curwen's own labels depicting a printer at work. This striking label, printed in primary colours, is very much in keeping with Harold's 'Spirit of Joy' and shows an acute awareness of the German and Dutch *Jugendstil*. The 'Orders and

Payments to Artists' book, in addition to listing specific orders,
divides the artists into categories – general, imaginative,
humorous, lithographers, fashion, scraperboard, etc. Phœbe
Stabler is listed under heraldry, Paul Nash under imaginative and
pattern, Ravilious under lithography, pattern and wood
engraving, and Edward Bawden, who became virtually an
'in-house' artist from the mid-'20s, appears most frequently as
qualified to produce imaginative and humorous drawings, as
well as pattern, lettering and maps. 'Pattern' was an important
category and the designing and printing of pattern papers, which
were retailed through prestigious stores such as Heal's and
Fortnum & Mason, as well as Muriel Rose's Little Gallery, became
a core part of the business. Virtually every one of the Curwen
artists, from Dora Batty to Graham Sutherland, designed such
papers and Paul Nash claimed that he found considerable
stimulus in the discipline, which gave him a compelling reason
for exploring the creation of non-figurative forms. In 1924 he
had produced a dozen strongly patterned and daringly abstracted
woodcuts to illustrate the first chapter of *Genesis*, which Curwen
printed for the Nonesuch Press. Bawden, in addition to pattern
papers, created a remarkable series of wallpapers, which he cut in
linoleum; Harold then skilfully transferred the images to
lithography, retaining all the textural quality and occasional
imperfections of the hand-blocked originals. These designs look
as fresh and spontaneous today as they did eighty years ago.

In addition to his mastery of offset lithography Harold also
pioneered, as far as England was concerned, the *pochoir* technique
of hand-stencilling. *Pochoir*, as its name suggests, had been
developed in France; it required considerable discipline, not only
from the artist, but also from the stencil-cutter and the
executants. Curwen taught himself how to interpret the artists'
work and also to cut the stencils. 'The next step', as Herbert
Simon says, was to train a member of staff to 'mix colours and
generally supervise the team of bindery girls. Irene Fawkes was
the first to take charge, then Lily Chick and when Miss Chick left

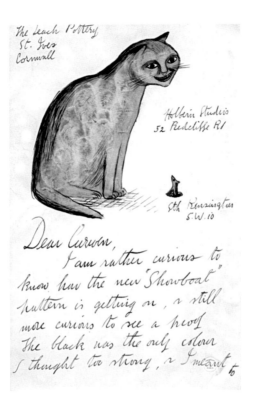

The Leach Pottery
St. Ives
Cornwall

Holbein Studios
52 Redcliffe Rd

Sth Kensington
S.W. 10

Dear Curwen,
I am rather curious to
know how the new "Showboat"
pattern is getting on, & still
more curious to see a proof
The black was the only colour
I thought too strong, & I meant to

Before mobile phones, or even telephones with wires, were common, letter writing was the usual form of long distance communication. Edward Bawden throughout his life wrote entertaining letters, frequently illustrated with human faced cats. This letter written early in his relationship with the Curwen Press was addressed from Bernard Leach's pottery in Cornwall where Charlotte, a potter and Bawden's future wife, was working. The 'Showboat' pattern, perhaps a design for a wallpaper, remains a mystery.

the firm to get married, the supervising was taken on by
Gertrude Temkin, who was at that time showing her remarkable
ability as a typographer working within the Curwen-Simon
tradition.'[10] Hand stencilling, apart from reproducing both the
texture and vibrancy of the artist's original watercolour, was, for
relatively short runs – those of less than a thousand copies –
actually more economic than machine printing. Albert
Rutherston, Edward Bawden and Barnett Freedman all produced
stencil work, though the latter preferred hand-drawn lithography,
but the outstanding masters were McKnight Kauffer and Paul
Nash. Considering the fact that Curwen only adopted the process
in the mid-'20s, it is a tribute to his skills, and those of his team
of young ladies, that Zwemmer's were able to mount an
exhibition, 'Stencilling from the Curwen Press', in 1931, which
was described by one reviewer as 'a feast for the modern
bibliophile'.[11] The highlight of the show was Arnold Bennett's *Elsie
and the Child* illustrated by McKnight Kauffer and published by
Cassell's in 1929. Paul Nash, in a draft review for *The Bibliophile's
Almanack*, wrote, 'The Stencil Department of the Curwen Press has
for many years produced every reasonable effect demanded of it
by illustrators but in the reproduction of the drawings for *Elsie and
the Child*, spurred on by Mr Kauffer, it seems to have jumped into
the realms of improbability. It is not reasonable to expect such
work – even from Mr Curwen's young ladies. But it has been
done, and personally I am still marvelling'.[12] 'Mr Curwen's young
ladies' were to excel again, not only for Kauffer, but for Nash
himself. In 1931 Cassell's published a further Arnold Bennett
novel, *Venus Rising from the Sea*, with twelve superbly reproduced
illustrations by Kauffer, and the following year Sir Thomas
Browne's *Urne Buriall and the Garden of Cyrus*, with thirty drawings by
Paul Nash, which Herbert Read considered 'one of the loveliest
achievements of contemporary English art'.[13]

Nash was not known for paying lavish compliments, but in a rare
tribute he wrote to Harold Curwen the following January saying:
I have only just recently been able to compare the plates you did

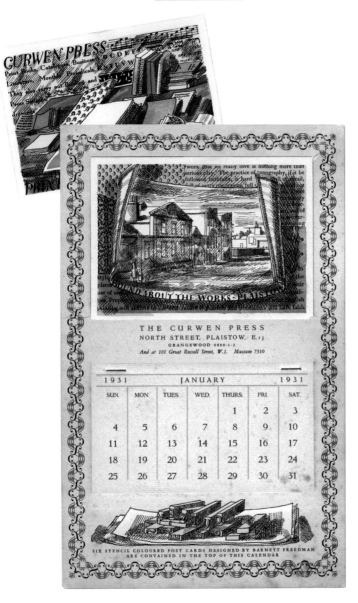

Curwen's most ambitious calendar, for 1931, contains six stencilled postcards by Barnett Freedman illustrating the Press and its activities. The cards are held behind a celluloid window at the top of the calendar.

for Urne Buriall with my original coloured proofs. I should like to tell you how very good I think the stencil work is. Mostly it is quite astonishing for its accuracy of interpretation, considering how insensitive the collotypes are and that you were obliged to slightly strengthen my colours (which alarmed me to contemplate). I must say I think your people surpassed themselves in their understanding of the problem. The only plate that went wrong was the 'Vegetable Creation' where they got the colours too hot and just somehow *not* mine.[14]

Perhaps this final quibble was a riposte to Oliver Simon, who had written to him a few months previously: 'Perfection I know will elude us, as usual. Even our Reader has spent a sleepless night on what is after all not his affair, but he has discovered that your convolvulus twines clockwise instead of anti-clockwise!!'.[15]

Urne Buriall marks the acme of Harold's achievement. Sadly though, it was to be the last of the *pochoir*-printed books, after which the highly skilled team of stencillers was disbanded. The Wall Street Crash, followed by the Depression, combined with the investment that Harold's cousin, Kenneth, had made in the development of 'Synchrophone' – an abortive system for adding sound to film – had taken a heavy toll, with the result that the business had to be drastically restructured. The music division was hived off and, on 1 March 1933, J. Curwen & Sons Ltd. became the Curwen Press Limited with Harold Curwen, Oliver Simon and his brother, Herbert, as directors. Herbert Simon – known as Bobby – came in at this time from the Kynoch Press in Birmingham; he had previously worked in the United States in the cotton business but, like his brother, had fallen under the spell of the printed word and had left in 1920 to study with the great American typographer, Bruce Rogers. When Oliver learnt that his brother had, as he called it, 'crossed the Rubicon', he wrote joyously: 'I conjure up visions of us setting up the "Marigold Press" in Hammersmith Mall, under the shade of Doves & Kelmscott Presses one of these days!! Whoo-ooo-oo-oop'.[16]

The Kynoch Press was a division of Imperial Chemical Industries, having been set up originally in the 1870s to print the cases of sporting cartridges and wrappers for military ammunition. Under Herbert's management, and that of his immediate predecessor, the scope of the business had expanded considerably, earning it the reputation of being a 'typographically lively firm, with few rivals in terms of typefaces, design and general printing work – a press for the typographic connoisseur'.[17] Herbert was an ardent advocate of English letter-forms and commissioned two decorative display faces, one from Donald Ewart Milner and the other from Eric Ravilious, who also engraved the blocks for the 1932 Christmas production of *The Kynoch Press Notebook*. The overlap of interests with Curwen was considerable and when Herbert moved south to join his brother he brought not only his own expertise, but also several colleagues, such as Donald Hope, as investors in the business, as well as a following of faithful friends and supporters who transferred their printing requirements to Plaistow. This Midlands connection was known in the works as 'the Staffordshire Knot'.

Following the restructuring the Curwen Press had a further forty years of distinguished work ahead both in the printing of books, particularly those illustrated by Barnett Freedman, as well as jobbing work, including some of the finest posters for the London Underground by Bawden, Wadsworth, John Banting, Betty Swanwick, Barnett Freedman and others. One of Freedman's first designs for Curwen was the jacket, depicting the tools of the trade, for Harold Curwen's *Processes of Graphic Illustration*. He was the ideal artist for this project, being unique in the Curwen stable in preferring auto-lithography to any other method of reproduction; even the pattern paper he designed for them was lithographed by himself, the only one to be produced in this manner.[18] He also illustrated several of the Faber Ariel Poems as well as such classics as *Lavengro, War and Peace* and *Anna Karenina* for the Limited Editions Club, New York, though the latter was printed at the Cambridge University Press rather than at Plaistow. According to John Dreyfus, who saw this monumental work through the press,

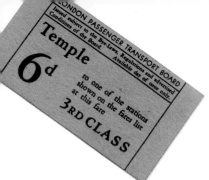

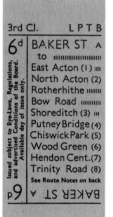

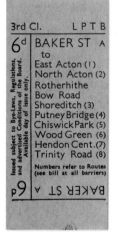

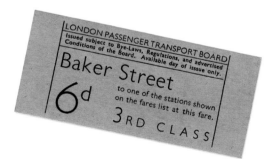

Trial designs of tube tickets, letterpress proofs
printed in Gill Sans Light and Cloister Bold.

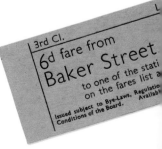

Freedman spoke about his 'constant attendance at Curwens', but Dreyfus suggested that 'the use of the word "constant" in this context was perhaps as accurate as a notice proclaiming that "garage doors are in constant use"'.[19] In fact Curwen delivered the huge lithographic stones to Freedman's studio where he rigged up a contrivance which enabled him to raise them to the height of his workshop table, and it was here that most of the work was done. A nice footnote to this close identification between Barnett Freedman, Harold Curwen and Oliver Simon is provided by Stanley Morison, who, in response to an enquiry from Walter Lewis, the Cambridge University printer, as to whether he liked Freedman's King George V Silver Jubilee stamps, replied that they were 'not as bad as I expected – a little Curwenpressish'.[20]

Since the early days of the DIA Frank Pick had been a staunch supporter and patron of the Curwen Press and during the second half of the '30s he commissioned not only posters such as Edward Bawden's 'Kew Gardens' and its partner, 'St James's Park', but instigated a rethink of the design of the London Passenger Transport Board's tickets for both tube and bus travel. Pick, and his assistant, Christian Barman, gave tickets high priority, regarding them as 'the visiting cards of London Transport', as they are described in the minutes of a meeting of 7 November 1937 between Barman, Harold Curwen and representatives of both the Monotype Corporation and Waterlow & Sons.[21]

The printing of vast quantities of tickets, and other long runs such as railway timetables, had been greatly facilitated, following the restructuring of the business, by the scrapping of some of the older machinery designed for printing sheet music and the installation of new equipment. Another innovation was the clearing of the music store and its conversion to a bindery with folding, sewing, and stitching machines as well as guillotines so that runs of 100,000 copies of pamphlets, etc. could be handled easily and speedily. Herbert Simon, the 'new broom', as he discreetly describes himself in *Song and Words*, was responsible for much of this innovation, whilst

his brother, Oliver, was immersing himself in his latest publication, *Signature*, described as a 'quadrimestrial of typography and the graphic arts'. *Signature* was Oliver's own property, but it was printed at Plaistow. The first issue appeared in November 1935 and the list of advertisers who supported it reads like a roll-call of old clients – the Westminster Bank, Shell, Bumpus's Bookshop, the Kynoch Press and the Curwen Press News-letter. The latter was a quarterly publication, instigated in 1932 to flaunt the capabilities of the Press, and, as the first issue shamelessly proclaims, 'It carries no disguise; it is guiltless alike of falsehood and modesty'.

Harold Curwen suffered from severe bouts of depression and in the '30s gradually withdrew from active participation in the firm. He married for the third time in 1940 and moved to Henley, where he and his young Norwegian wife ran the North End Stores. Business at Plaistow was anyway to be virtually brought to a halt later in the year when bombs totally destroyed the works, with the exception of the old Independent Chapel, where the Revd. John had set up his original press. Two employees – Miss Benzing and Miss Cooper – sent Harold a full account of the damage written in *Hiawatha*-esque verse, beginning:

> As you enter what was Curwen's
> Through the broken glass and tiling,
> You behold the office remnants
> Lying on the wooden flooring

In his reply Harold managed, despite the difficulties of wartime conditions, to paint a reasonably idyllic vision of life in rural Buckinghamshire: 'Here we stagger under problems of rationing and sacks of rice or sides of bacon and try to cut them up nicely and serve them as best back rashers.[...] We give the road man a drink and he brings us loads of Buckinghamshire leaf-mould and we dig it into the soil and make us a plantation of wild strawberries out of the hedgerows and set cuttings of Quince and propagate the Horse-radish and the berries that are so good in

Sales

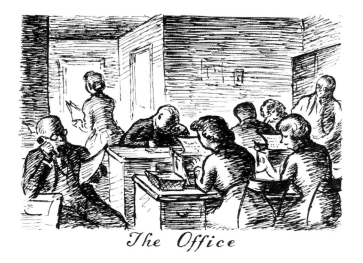

The Office

Edward Ardizzone was commissioned to illustrate the Works, inside and out, for the May 1938 *Curwen Press News-Letter* 15. 'Taking a modern novel as a precedent we may say "all the characters are purely fictitious". 118 men and women were employed in 1924; during the present year the permanent staff has grown to 150. Of this total, 25 craftsmen and women have been with the Curwen Press a quarter of a century or more.'

early summer'.[22] Oliver Simon's wife sometimes assisted them, as he told Paul Nash that autumn: 'Curwen's shop and post office is a very cosy affair and Ruth has plenty of occupation helping'.[23] North End Stores was reputed to have some of the best printed and lettered jars, drawers and boxes in the country, which is hardly surprising considering that Harold had designed a distinguished sans serif face some thirty years previously – several years before Johnston's own Underground lettering. By chance, Paul Nash, in one of his earlier articles for the Curwen Press News-letter, had picked on the 'crudeness and vulgarity of design' of the myriad boxes, bottles and tins in the ordinary grocer's shop, which he described as both 'incalculable' and 'indescribable'.[24] The fine lettering at North End Stores was not the only vestige of Harold's first and greatest love; in 1948 he wrote the text for the Puffin Picture Book, Printing, in which, accompanied by Jack Brough's illustrations, he told in simple terms the story of printing from the days of the medieval scribe to photogravure and offset lithography.

Harold had once declared, in a lecture he gave in 1921, that 'A small piece of fine work and paper is more desirable and of better effect than a large pretentious piece of shoddy'.[25] Over the next two decades, with this principle in mind, he, along with Oliver and Herbert Simon, set about banishing 'shoddy' and placing the Curwen Press in the vanguard of a typographic revolution which made Plaistow an internationally renowned centre for fine printing, and the name of Curwen synonymous with excellence.

Peyton Skipwith

1. The text of this lecture was published in *The Caxton Magazine*, No.2, vol xxxi, February 1929.

2. Herbert Simon, *Song and Words: A History of the Curwen Press*, George Allen & Unwin, 1973, p.38.

3. Unpublished typescript by Thomas Balston, 1950, private collection.

4. Herbert Simon, op. cit., p.114.

5. *The Lenzerheide Chronicle: The Perspicuous Personalities of the Lenzerhorn Party*, 1911, compiled and privately printed by Stanley Unwin.

6. Thomas Balston, op. cit.

7. Herbert Simon, op. cit., p.190.

8. *Sunday Times*, 11 March 1956.

9. Cambridge University Library, Curwen Press Archive, Morison xxvii.158.

10. Herbert Simon, op. cit., p.212.

11. *Apollo*, vol.xi, no.63 (March 1930), p.228.

12. Cambridge University Library, Morison xxvii.323.

13. Herbert Read, *Philosophy of Modern Art*, London, 1952, p.180.

14. Paul Nash to Harold Curwen, 31 January 1933, Cambridge University Library, Morison xxvii.245.5.

15. Oliver Simon to Paul Nash, 2 October 1932, Tate Gallery, TGA 8313/1/2/76.

16. Cambridge University Library, Morison xxvii.32.

17. Dr Caroline Archer, *Eric Ravilious and the Kynoch Press*, The St Bride Notebook, Incline Press, 2003.

18. Auto-lithography was the subject of an essay by Desmond Flower in the *Curwen Press News-Letter*, No.10.

19. Ian Rogerson, *Barnett Freedman: The Graphic Art*, The Fleece Press, 2006, p.72.

20. Nicholas Barker, *Stanley Morison*, Macmillan, 1972, p.337.

21. Cambridge University Library, Morison xxvii.119.

22. Letter dated 25.11.40 from North End Stores, Henley, Cambridge University Library, Morison xxvii.298.

23. Oliver Simon to Paul Nash, 12 October 1940, Tate Gallery, TGA 7050/568.

24. *Curwen Press News-Letter*, No.8.

25. Cambridge University Library, Morison xxvii.107.

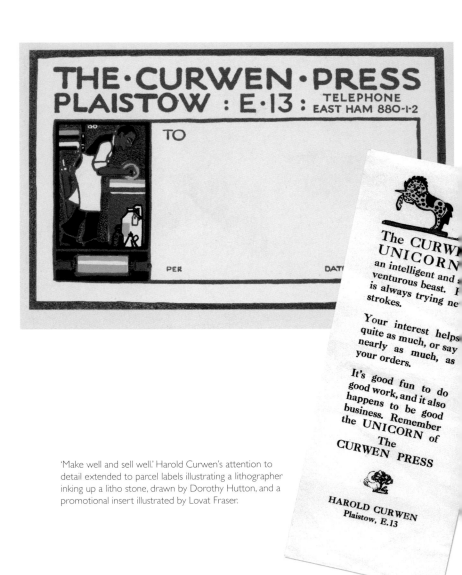

'Make well and sell well.' Harold Curwen's attention to detail extended to parcel labels illustrating a lithographer inking up a litho stone, drawn by Dorothy Hutton, and a promotional insert illustrated by Lovat Fraser.

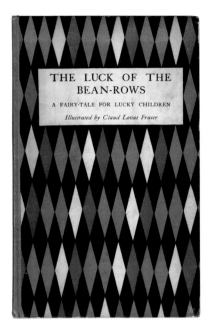

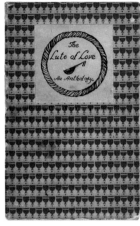

" It is I, it is Pea-Blossom,"

The Luck of the Bean-Rows by Charles Nodier, published by Daniel O' Connor, 1921 and *The Lute of Love* published in 1920 by Selwyn & Blount, were the first books illustrated by Lovat Fraser to be printed by Curwen. This copy of *The Lute of Love* was inscribed by John Piper in 1923; he was to work with Curwen in the 1930s.

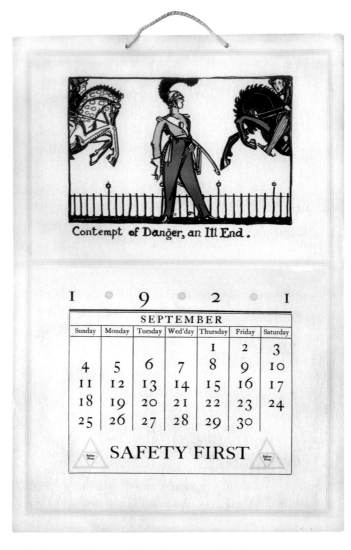

The Design and Industries *Safety First* calendar, 1921. The Council members of The Design and Industries Association who supported good design, together with Curwen, Thorp and Lovat Fraser, included Albert Rutherston, Frank Pick of the London Underground, Ambrose Heal, Harold Stabler of Poole Pottery and architects Sir Robert Lorimer and Charles Holden.

Introduced to Harold Curwen in 1919 by Joseph Thorp, Lovat Fraser's pen-drawn vignettes identified stationery, invitations and everyday printing for the Curwen Press and their customers.

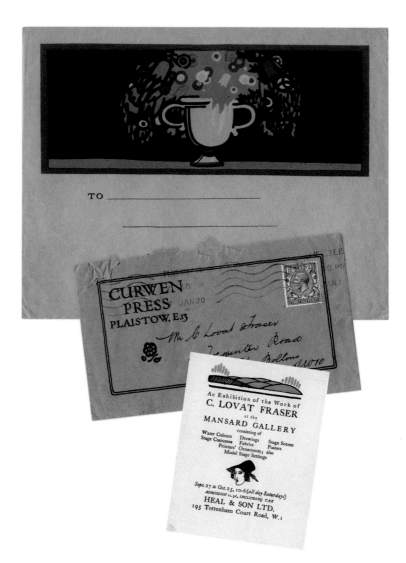

Before the First World War Lovat Fraser wrote
and illustrated a series of 'Flying Fame' hand
coloured chapbooks based on early 19th
century 'penny plain, tuppence coloured' prints.

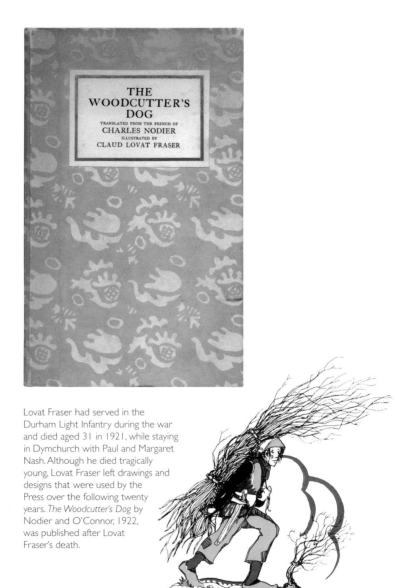

THE
WOODCUTTER'S
DOG
TRANSLATED FROM THE FRENCH OF
CHARLES NODIER
ILLUSTRATED BY
CLAUD LOVAT FRASER

Lovat Fraser had served in the
Durham Light Infantry during the war
and died aged 31 in 1921, while staying
in Dymchurch with Paul and Margaret
Nash. Although he died tragically
young, Lovat Fraser left drawings and
designs that were used by the
Press over the following twenty
years. *The Woodcutter's Dog* by
Nodier and O'Connor, 1922,
was published after Lovat
Fraser's death.

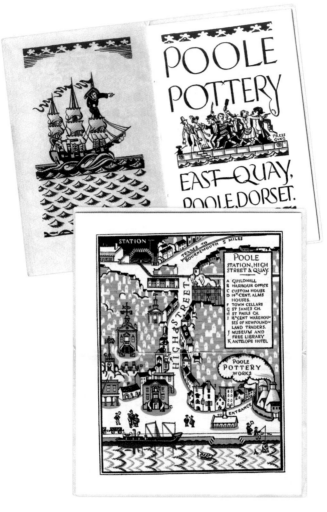

Harold Stabler, the distinguished silversmith and director of Poole Potteries, proposed Harold Curwen for the Council of the DIA. Stabler had commissioned Edward Bawden to design a calendar for his company in 1924 while he was still a student at The Royal College of Art and in 1925 Bawden drew the illustrations, including a decorated map for the Poole booklet. *Opposite*, a pattern paper designed by Bawden in 1927, commissioned by The Westminster Bank; it appears not to have gone beyond the proof stage.

December, printed by Curwen for Chatto & Windus. Their 1927
Almanack contains 24 full page and head piece seasonal line drawings,
and a redrawing of their imprint for the title page, by Stanley Spencer.
Published in an unlimited edition in paper covers and with a special
edition of 250 copies bound in linen with dyed paper boards.

February

August

September

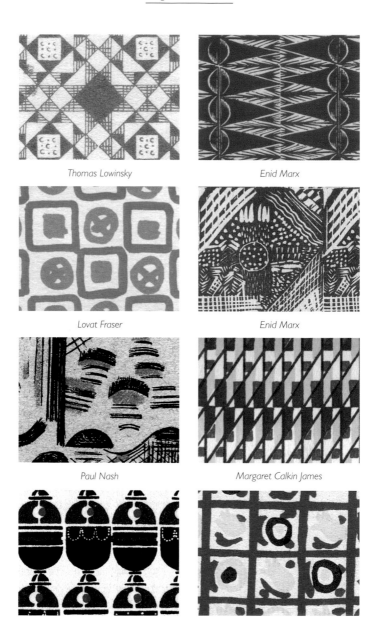

Thomas Lowinsky

Enid Marx

Lovat Fraser

Enid Marx

Paul Nash

Margaret Calkin James

Lovat Fraser

Lovat Fraser

Pattern papers from *A Specimen Book of Pattern Papers, for and in use at* The Curwen Press, 1928.

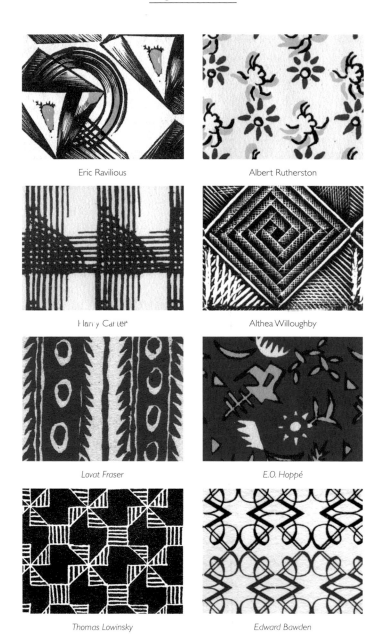

Eric Ravilious

Albert Rutherston

Harry Carter

Althea Willoughby

Lovat Fraser

E.O. Hoppé

Thomas Lowinsky

Edward Bawden

Sold in the United States as *St Albans side and end papers* by the Japan Paper Company.

CURWEN POSTER TYPE AND POSTER BORDER. TYPE DESIGNED BY HAROLD

$4\frac{1}{2}$ LINE

OPQRSTUV

6 LINE

abcdefgho
ABCDEM
HJKNOP

abc

AB

hik

A Specimen Book of Types and Ornaments in use at The Curwen Press, published by Oliver Simon, *The Fleuron,* 1928. The Curwen Poster Type, designed by Harold Curwen and HK Wolfenden, with borders by Enid Marx is printed as a double page spread and gatefold. Harold Curwen's Curwen Sans Serif was designed in 1911, cast in 1928 and shown in the *Curwen Press Miscellany* in 1931. The typeface shows the influence of Edward Johnston, Harold Curwen's teacher and designer of the London Underground type.

D H. K. WOLFENDEN. BORDER DESIGNED AND CUT ON WOOD BY ENID MARX

10 LINE

efm **ABCK**

12 LINE (Capitals only)

DR **ORT**

mn

In addition to the sizes shown, the Curwen Poster Type
is also cut in 14, 16, 18, 20 and 22 line

ABCDEFGHIJKL
MNOPQRSTUV
WXYZ&
1234567890

49

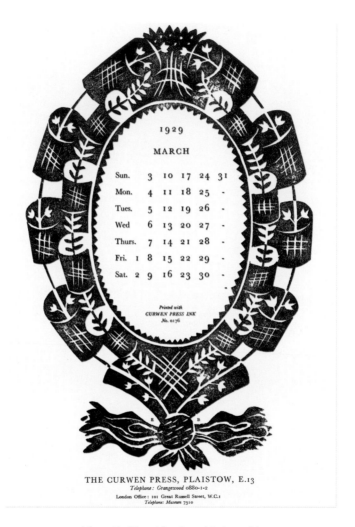

A linocut by Edward Bawden printed as an ink
colour chart for the 1929 Curwen calendar.

The Stencil Process at the Curwen Press was published in 1928. The front cover uses a Lovat Fraser drawing and the introductory text is set in Koch Kursiv, as is Harold Curwen's letterheading. Both were delivered in a hand-made envelope made from an Enid Marx pattern paper.

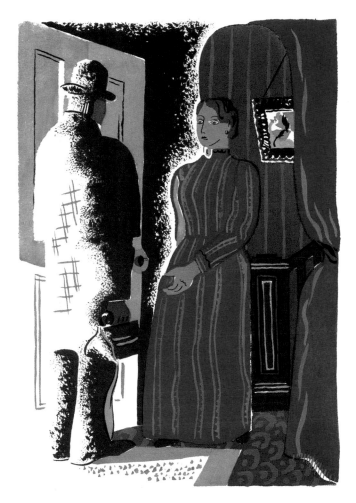

One of ten illustrations, by McKnight Kauffer, stencilled in gouache for *Elsie and the Child,* by Arnold Bennett, 1929. Harold Curwen, having studied French *pochoir* printing, interpreted the artist's artwork and initially cut the stencils himself. He went on to train a team of stencillers drawn from girls in the Curwen bindery.

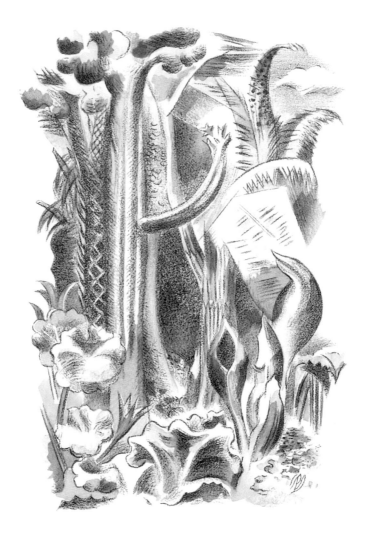

'Vegetable Creation' from Paul Nash's *Urne Buriall and the Garden of Cyrus*, 1932. The black key drawings are printed in collotype with stencils applied in watercolour. Although the author and critic Herbert Read thought the book ' a lovely achievement', Nash, ever critical, but otherwise complimentary of Curwen's work, thought this illustration was 'too hot'.

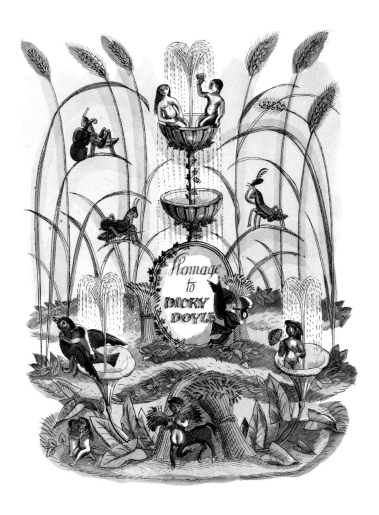

'*Homage to Dicky Doyle*', Richard Doyle was one of Edward Bawden's favourite
Victorian illustrators. The drawing is stencilled in watercolour as an example for
The Curwen Press Miscellany, edited by Oliver Simon, 1931.

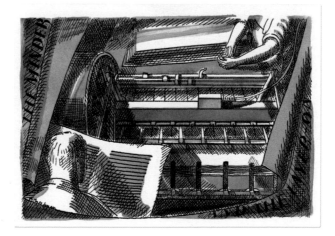

Barnett Freedman, stencilled postcards from the 1931 Curwen calendar, *Typography*, the start of the printing process and the *Layer-on* and *Minder* checking printed sheets.

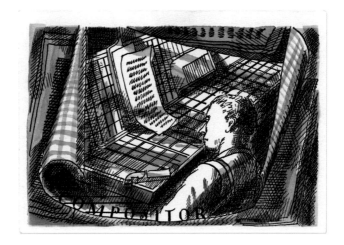

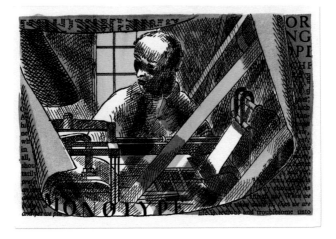

The *Compositor* is setting metal type by hand and the *Monotype* operator is setting and casting individual letters into lines of text on an automated Monotype machine.

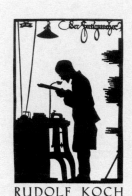

RUDOLF KOCH

THE TWENTY-SIXTH DINNER
OF THE DOUBLE CROWN CLUB
23 MAY 1930 AT KETTNER'S
RESTAURANT SOHO WITH R ·
W · CHAPMAN IN THE CHAIR
AND RUDOLF KOCH WHO WILL
READ A PAPER & ELMER ADLER
AS THE GUESTS OF THE CLUB
FARE: GRAPE-FRUIT COCKTAIL
OR HORS-D'ŒUVRES + BISQUE
D'HOMARD + SAUMON POCHÉ
SAUCE HOLLANDAISE + SELLE
D'AGNEAU NIVERNAISE AVEC
POMMES RISSOLÉES & SALADE
CAPRICE + TRIFLE POUDING ET
FRIVOLITÉS + CAFÉ FRANÇAIS

THE TWENTY-SIXTH DINNER
OF THE DOUBLE CROWN CLUB
23 MAY 1930 AT KETTNER·S
RESTAURANT SOHO WITH R·
W. CHAPMAN IN THE CHAIR
AND RUDOLF KOCH WHO WILL
READ A PAPER & ELMER ADLER
AS THE GUESTS OF THE CLUB
FARE: GRAPE·FRUIT COCKTAIL
OR HORS·D·OEUVRES ⁄ BISQUE
D·HOMARD⁄SAUMON POCHÉ
SAUCE HOLLANDAISE ⁄ SELLE
D·AGNEAU NIVERNAISE AVEC
POMMES RISSOLÉES & SALADE
CAPRICE ⁄ TRIFLE POUDING ET
FRIVOLITÉS⁄CAFÉ FRANÇAIS

THE TWENTY-SIXTH DINNER
OF THE DOUBLE CROWN CLUB
23 MAY 1930 AT KETTNER'S
RESTAURANT SOHO WITH R
W. CHAPMAN IN THE CHAIR
AND RUDOLF KOCH WHO WILL
READ A PAPER & ELMER ADLER
AS THE GUESTS OF THE CLUB
FARE · GRAPE-FRUIT COCKTAIL
OR HORS-D'OEUVRES ✦ BISQUE
D'HOMARD ✦ SAUMON POCHÉ
SAUCE HOLLANDAISE ✦ SELLE
D'AGNEAU NIVERNAISE AVEC
POMMES RISSOLÉES & SALADE
CAPRICE ✦ TRIFLE POUDING ET
FRIVOLITÉS ✦ CAFÉ FRANÇAIS

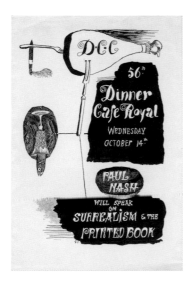
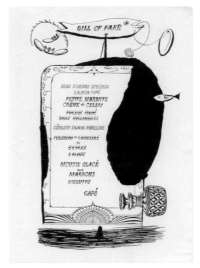

Double Crown Club menus. Dinner 56 illustrated by Graham Sutherland, 'Fish wine' and 'Speaker ham' are not on the menu. The menu for Dinner 26, 23 May, 1930, *opposite*, with a self portrait silhouette of the speaker Rudolf Koch on the cover. The following pages are set in Koch's Neuland, Maximillian and Kursiv. An errata slip states: *The incompetent and careless designer of this menu, which is set in three of the typefaces of Rudolf Koch, feels that the pedants may notice that the dating of the menu is not strictly accurate. In these circumstances he prefers to remain anonymous. May 22 (not 23), 1930.*

GAIETY AND GHOSTS

BREAK OF DAY

ABOVE AND BELOW

Chapter headings from *East Coasting* by Edward Bawden.

STATIONS OF THE PAST

THE FIERCEST FIGHT OF ALL

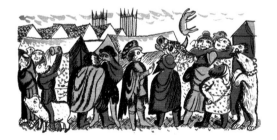

EMBLEMS OF ENGLAND

Published by the London and North Eastern Railway, 1931.

We are three minutes' walk from Plaistow Station on the District Railway, reached by direct train from Sloane Square, Charing Cross (35 mins.), Cannon Street, etc.

Edward Bawden's Unicorn drawn for a Press postcard, 1934. Bawden was Curwen's most versatile and regularly used artist. As well as designing wallpapers for Curwen, posters for London Underground and advertising and publicity drawings for the Press customers, he was producing book illustrations for Faber and other publishers, drawings for advertising agencies and paintings for exhibitions. His first 'one-man' exhibition of watercolours at the Zwemmer Gallery was in 1933 followed by regular exhibitions at the Leicester Galleries from 1938. He exhibited regularly at the Royal Academy from 1948 and at the Fine Art Society from 1971 until his death in 1989.

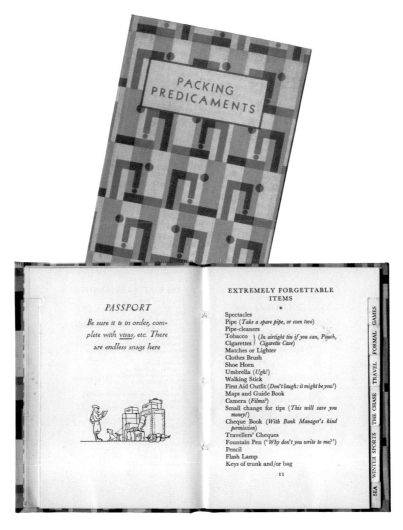

Packing Predicaments, 'First published 1931. Copyright throughout this and any other world,' a very tongue-in-cheek little book with printed cloth binding. 'Produced by Austin Reed's of Regent Street and dedicated to men who leave things behind.'

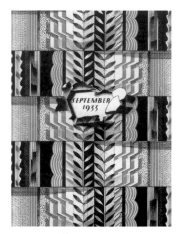

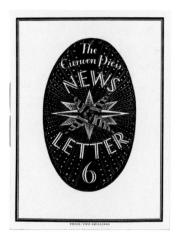

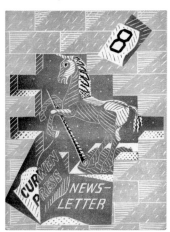

The Curwen Press News-Letter, first published in 1932 as a twice yearly magazine of developments at the Press, and as a showcase for fine printing and illustration.

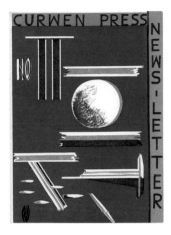

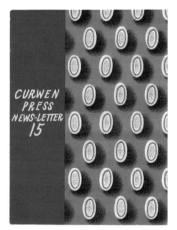
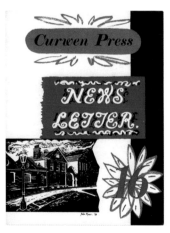

The News-Letters included covers and illustrations by Barnett Freedman, Eric Ravilious, Edward Bawden, Paul Nash, John Nash, Graham Sutherland and John Piper.

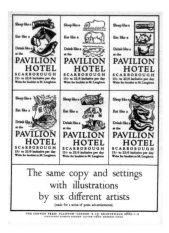

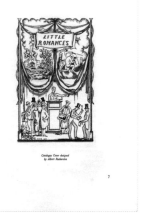

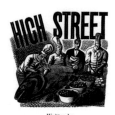

Examples of typography and illustration in letterpress and lithography, including a price list for Bawden's Curwen's 'Plaistow' wallpapers and title page from *High Street* by Eric Ravilious from Number 16, 1939, the last *News-Letter*. *Opposite*, a specimen of Curwen lithography by Barnett Freedman from *News-Letter 10*, 1935.

*Spine and side of Book Jacket, designed and drawn
on the stone by the artist*

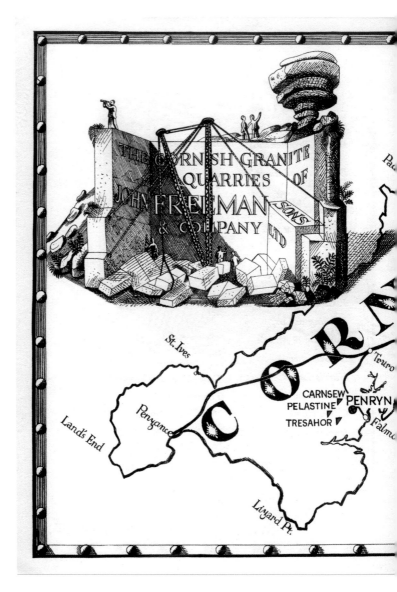

Cornwall, the Cornish Granite Quarries of John Freeman,
Sons & Company Ltd drawn by Edward Bawden.

Drawn for a publicity brochure and illustrated as a double
page spread in News-Letter 3, 1933.

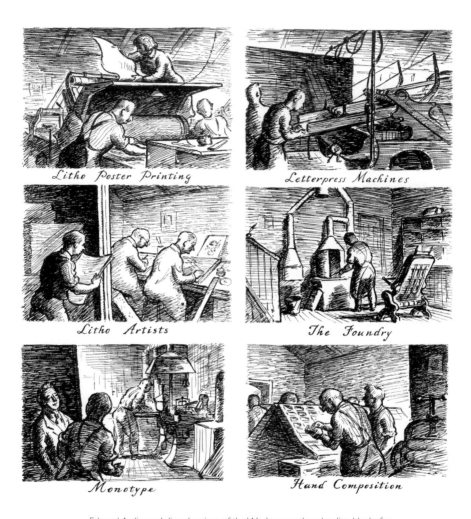

Litho Poster Printing

Letterpress Machines

Litho Artists

The Foundry

Monotype

Hand Composition

Edward Ardizzone's line drawings of the Works reproduced as line blocks for News-Letter 15, 1938. Although the editorial claimed that 'the characters are purely fictitious', Ardizzone's illustrations look like accurately drawn portraits of the Curwen staff.

The Bindery

The Van

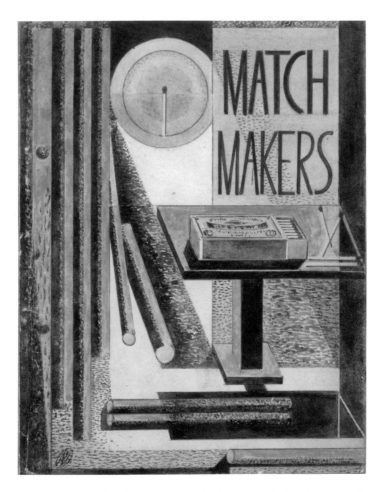

The original watercolour design by Paul Nash for the cover of *Match Makers*, renamed
Match Making when published for Bryant and May in 1937. The brochure contains
photographs of the matchmaking process by Francis Bruguière, Harold Curwen's
preferred industrial photographer. The text is set in large size Baskerville, with Curwen
Sans Serif headings.

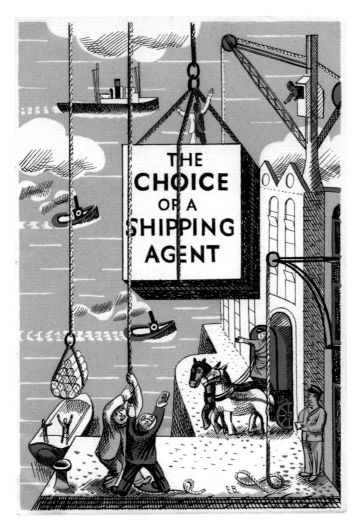

The 'plain cover' of *The Choice of a Shipping Agent*, set in small
type and printed on 'packing paper', opens to Edward Bawden's
delicious title page for Thomas Meadows & Co.'s brochure, 1931.

Curwen Types, a working handbook of types in use at the Curwen Press, January 1931.
The small format forty page booklet, an update on the 1928 Type Specimen Book, has
a cover photograph of Caslon type spelling the title (letterpress, in reverse). Further
editions were produced in the 1940s and '50s. The 1941 cover drawing is by Bawden.

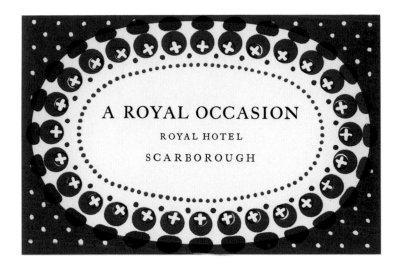

The Press printed menus, wine lists and leaflets for the hotels; the 1953 Queen Elizabeth II Coronation leaflet for the Royal Hotel, *A Royal Occasion*, announced, 'We have installed the very latest Television Projection Set…' and in a further pun on the hotel's name concludes… 'in the evening we will celebrate this *Royal Occasion* in a truly *Royal manner*'.

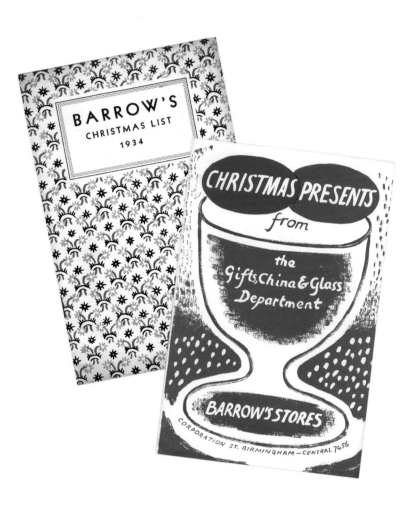

The Birmingham department store Barrow's were Design and Industries Association members and used Curwen artists to illustrate leaflets and publicity material. The 1934 *Christmas List* reproduces an Albert Rutherston pattern paper. The *Christmas Presents* cover is by Graham Sutherland.

The 1937 Country Life *Gardener's Diary*, commissioned by Noel Carrington, was designed and illustrated throughout with drawings by Edward Bawden, with weekly reminders from William Cobbett's *English Gardener*, 1827.

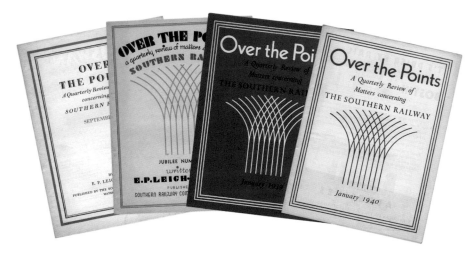

Over the Points was written by EP Leigh Bennett and later Michael Gifford, illustrated by Thomas Poulton and Victor Reinganum. At first distributed to first class season ticket holders as a PR exercise to explain the electrification of the railway, it was later delivered to twenty-five thousand regular travellers. *Over the Points* ran from 1929, stopped briefly in 1939 and continued through the war.

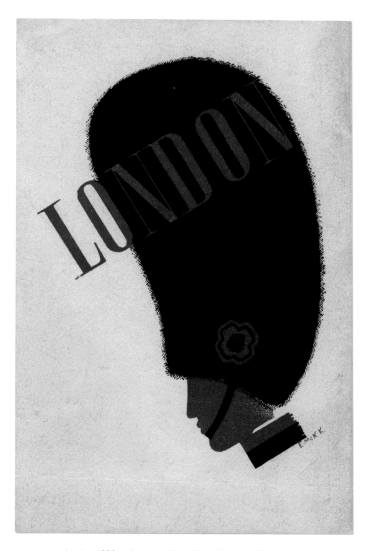

London, 1938, a photographic guide, with a cover illustrated by McKnight Kauffer, published by The Travel and Industrial Development Association.

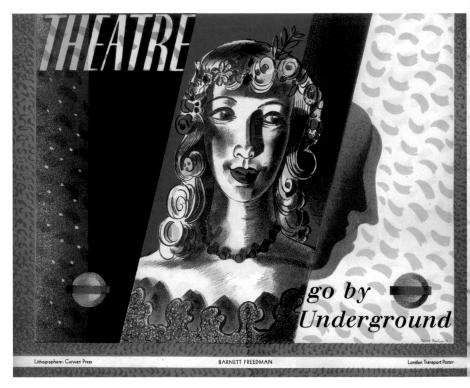

Theatre, with *Circus*, is one of a pair of posters drawn by Barnett Freedman and lithographed by Curwen for London Underground in 1936 and used as an insert to illustrate British design and printing in the German magazine *Gebrauchsgrafik*.

A menu by Barnett Freedman for Jack Beddington, the renowned publicity manager of Shell-Mex from 1929-1939, commissioner of young untried artists, as well as the trusted Bawden, Kauffer, Paul Nash and Freedman.

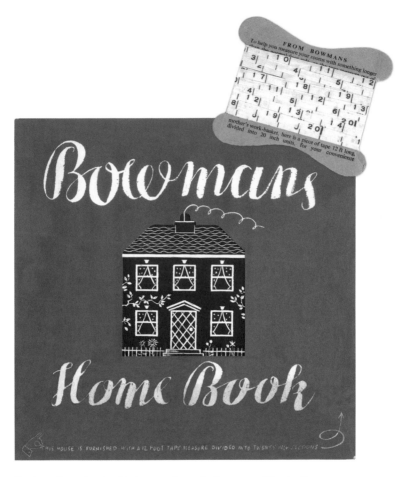

Two large format 'modern' furniture catalogues for Bowmans of Camden Town, designed and produced by the Stuart Advertising Agency, one of Oliver Simon's clients, printed by Curwen, 1938 and 1939. The cut out house, attached to the front cover of the *Home Book*, contains a twelve foot tape measure. Edward Bawden, who Stuarts commissioned to draw advertisements and leaflets for Fortnum and Mason, drew the title page for the catalogue, *opposite*. Under the horse drawn van Bawden has written 'But of course <u>ours</u> are motor vans.'

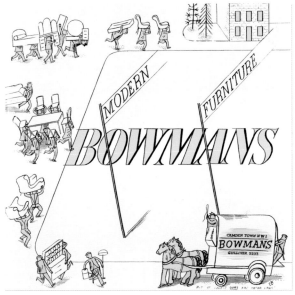

After Hours

The Local, a book of pubs, probably Edward Ardizzone's favourite subject as illustration, with words by Maurice Gorham, published by Cassell & Co. *The Local* was lithographed at Curwen in 1939. It was followed in 1949 by *Back to the Local,* illustrated this time by line drawings. Gorham's introduction remarks that the unsold copies, sheets and plates of the pre-war book were destroyed in the burning of Cassell's premises.

Approach to Gordale Scar *Yorkshire*

Park Place *Berkshire*

English, Scottish and Welsh Landscape, 1700-c1860, chosen by John Betjeman and Geoffrey Taylor with original lithographs by John Piper. One of the series of *New Excursions into English Poetry,* published by Frederick Muller, 1944.

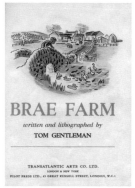

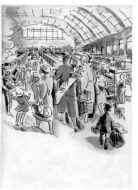

Tom Gentleman was an artist and poster designer working for Jack Beddington in the Shell-Mex design studio. His book for children, *Brae Farm* was printed at Curwen in 1945.

Travellers' Verse from the *New Excursions into English Poetry* series, 1946. Chosen by Gwenyth Lloyd Thomas and with lithographs by Edward Bawden. Other illustrators in the series included John Craxton, Michael Ayrton and William Scott.

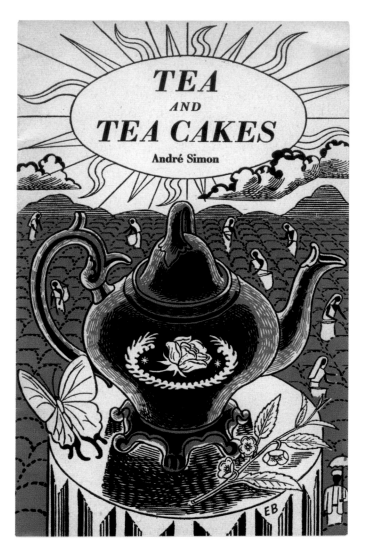

Edward Bawden's pre-war reputation as a painter was confirmed by his work as an official war artist during the Second World War. In 1946 he was awarded a CBE and became an Associate of the Royal Academy. His association with the Curwen Press resumed with *Tea and Tea Cakes*, a history of tea and recipe book published by The Wine and Food Society and The Empire Tea Bureau, 1946.

Tea and Tea Cakes

How to make Tea

'Teas — not just Tea'

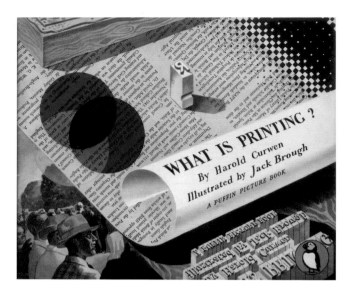

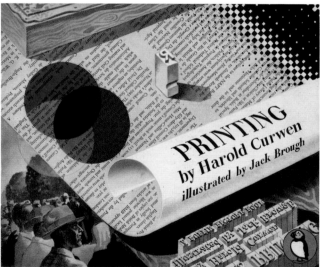

'Printing grew from writing. This little book is produced by "Letterpress" printing in many colours' was how Harold Curwen began his still informative Puffin Picture Book in 1948. After the proof book was produced the title, but not the cover illustration, was revised to *Printing*.

Curwen Press Publications
1920-1950

Apropos the Unicorn
By Joseph Thorp, illustrated by Claude Lovat Fraser, 1919-20.

The Four Seasons
A calendar illustrated by Albert Rutherston, 1922.

Catalogue Raisonné of Books printed at The Curwen Press
1920-1923. Introduction by Holbrook Jackson. 1924. 400 copies.

The Fleuron, vols I-IV
From 1922, edited by Oliver Simon (vols V-VII edited by Stanley
Morison, printed at Cambridge University Press).

The Curwen Press Almanack for 1926
Illustrated by Randolph Schwabe. 425 copies.

A Specimen Book of Types and Ornaments in use at The Curwen Press
1928. 135 copies.

A Specimen Book of Pattern Papers designed for and in use at The Curwen Press
Introduction by Paul Nash. 1928. 220 copies.

The Stencil Process at The Curwen Press
Introduction by Holbrook Jackson, 1928.

How to Buy and Sell Money, 1929.

The Curwen Press Miscellany
Edited by Oliver Simon. 1931. 275 copies.

Something to Think About, 1932.

The Curwen Press News-letter, 1932-39.

Typefaces in use at The Curwen Press
1931-'40s.

Signature. First Series, 1935-1939. Second Series 1945-1953
Edited by Oliver Simon.

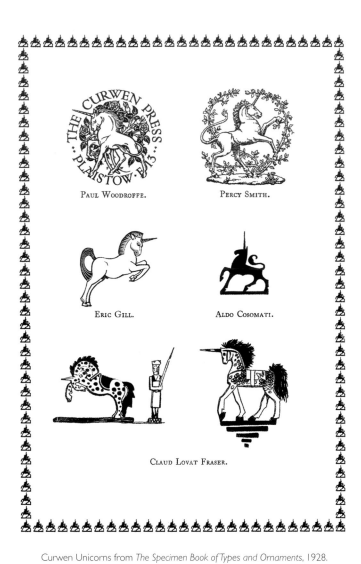

Curwen Unicorns from *The Specimen Book of Types and Ornaments*, 1928.

The stencilled frontispiece, initial (page 5) and tailpiece (page 34) drawn by Edward Bawden illustrate Paul Nash's essay on 'The Curwen Stencil Process' in *The Specimen Book of Pattern Papers, 1928*.

The *Red No.1* and *Blue No.19* used for this book's covers and endpapers are from the Curwen ink chart, News-Letter 6, 1934, and the title is set in Walbaum, one of Curwen's 'house' typefaces.